MAYOR

In the Company of
NORMAN RICE
Mayor of Seattle

Written and photographed by
RICHARD SOBOL

Foreword by Norman Rice

Government in Action Series

COBBLEHILL BOOKS
Dutton/New York

For my father, Herbert Sobol

Library of Congress Cataloging-in-Publication Data

Sobol, Richard.
 Mayor : in the company of Norman Rice, Mayor of Seattle / written and
photographed by Richard Sobol ; foreword by Norman Rice.
 p. cm. — (Government in action series)
 Summary: Describes eight busy days in the life of Norman Rice, mayor of
Seattle.
 ISBN 0-525-65198-5
 1. Mayors—Washington—Seattle—Juvenile literature. 2. Seattle (Wash.)—
Politics and government—Juvenile literature. 3. Mayors—United States—
Juvenile literature. 4. Rice, Norman. [1. Mayors. 2. Rice, Norman.
3. Seattle (Wash.)—Politics and government.] I. Title. II. Series.
 JS1455.4.A1 1996
 979.7′772043′092—dc20 95-21273 CIP AC

Published in the United States by Cobblehill Books,
an affiliate of Dutton Children's Books,
a division of Penguin Books USA, Inc.,
375 Hudson Street, New York, New York 10014

Designed by Charlotte Staub
Printed in Hong Kong First Edition
10 9 8 7 6 5 4 3 2 1

FOREWORD

I have one of the greatest jobs in the entire world. Through my work, I get to meet thousands of new people each year—to help them with their problems, or hear their ideas. There's never a dull moment— each day brings new challenges and new opportunities.

One day, I might be meeting with the President of the United States. The next day, I might be talking with students at a local school, or listening to homeless men and women talk about the problems they face, or working with police officers to make our community safer. That's what I love about being Mayor—every part of what I do is challenging and interesting, and together they add up to a rich and satisfying job.

As you will see from these wonderful photographs, I am also

blessed to be Mayor of one of America's greatest cities—Seattle. People always ask me what makes Seattle such a wonderful place. I tell them it's a lot of things—our beautiful mountains and forests and water, our bustling shops and strong neighborhoods, our wonderful parks and recreational opportunities.

But most of all, it's the people who make Seattle such a special place—people from all walks of life and from every corner of the globe. People in Seattle believe they can make their community a better place, and they work together to make their dreams a reality.

That's something I've always believed in—the power of people working together can overcome almost any challenge. I know that a lot of people helped me to get where I am today. That's why I believe the most important thing that any of us can do is to reach out our hand to someone else and help them along.

When you think about all the problems facing our world today, it's easy to get discouraged. Hunger, pollution, wars, violence, homelessness—it's easy to say "I'm just one person, what can I do?" As Mayor, I always say that one person can do a lot. Each of us has the potential to make a difference, to be a leader, to help others. If we reach out to each other, if we listen to the ideas and concerns of the people around us, if we work together in a spirit of cooperation, there is no mountain that we can't climb and no problem we can't overcome.

Norman B. Rice

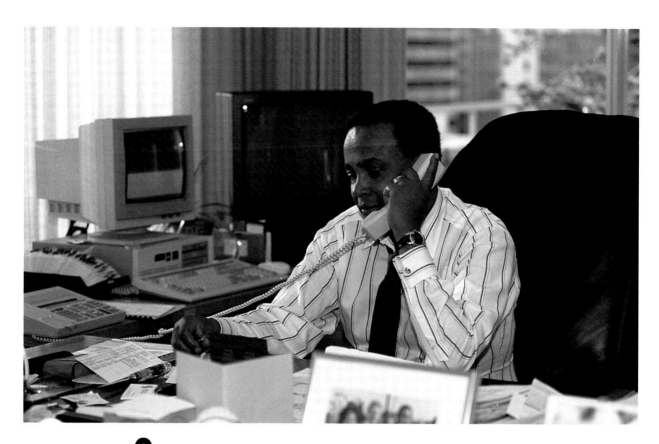

On my first morning in Seattle, I packed my gear and headed to an early-morning introduction to the Mayor. I found a map and searched for City Hall. I looked hard but couldn't locate it anywhere. Grabbing a ride from the courtesy van at The Edgewater Inn, one of Seattle's landmark hotels, I asked to be taken to City Hall. The driver, a Seattle native, looked puzzled and said, "Where is that? Do you mean the courthouse?" Being new to the city, I was taken aback and didn't know what to say. Together we went over the map and he couldn't find it either. He thought the courthouse would be a good place for me to start looking and after he dropped me there I continued to ask for City Hall, only to be met with another series of blank stares. Now I was getting nervous and beginning to feel the weight of the two bags of camera

equipment that I hadn't expected to drag around downtown Seattle. In desperation I finally started asking for the Mayor's office and that brought positive results. A sidewalk expresso-seller directed me to the Municipal Building and sent me up to the twelfth floor, where I finally caught up, a few minutes late, with Mayor Norm Rice. From that day on in Seattle, I played a game every morning, asking cabdrivers and hotel drivers to take me to City Hall, smiling to myself as not *one* of them identified the right building!

There is no ornate City Hall in Seattle. No grand marble columns or golden domes in this city of just over a half a million people who take pride in their reputation for practicality and understatement. The Mayor's office itself can only be described, in politest terms, as "ordinary." Someone less polite might call the Municipal Building that houses the Mayor and other city employees drab. The covered entryway, which serves as temporary shelter for the homeless, stands as a reminder of the challenges facing American cities. But once upstairs, one could gaze for hours at the view from Mayor Rice's office, studying

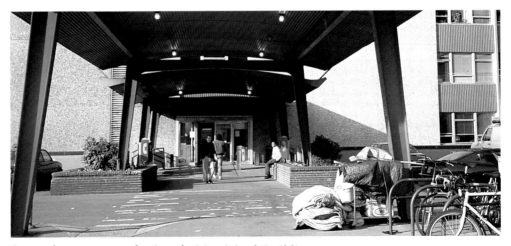

Covered entryway to the Seattle Municipal Building

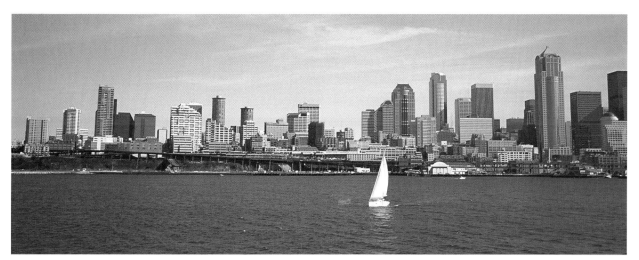

View of Puget Sound

the environment of the city dwellers—the concrete and steel office towers of the busy city center, the rushing lines of traffic, children on their way to school, adults at work, and a group of people whose faces and clothing show the strains of life as they wait in line for a free hot lunch at a neighborhood church. This view also includes the majestic world of nature, for outside the city you can admire the dramatic snowcapped peaks of Mount Rainier and the rest of the Cascade Range and Olympic National Park, as well as the bright blue open waters of Puget Sound. When gazing out from here it is easy for one's mind to wander, and for a Mayor to dream.

"When you are Mayor of a city you know that there is a legacy that you would like to leave behind. I think some Mayors can look at the permanence of a city by the buildings they create and the statues they dedicate. But I am more concerned with something else, the city's spirit. It's what I felt when I came to the Northwest. It's a spirit that understands that our fabric as a community depends on the strength of every thread. It's a spirit that combines compassion with practical solutions. I feel like I carry on the legacy of that can-do spirit that challenges people to make things better. I am a caretaker of this city and this tradition. It is

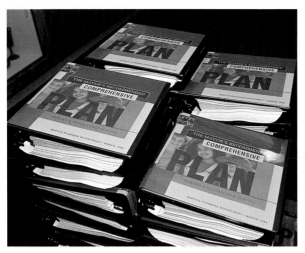
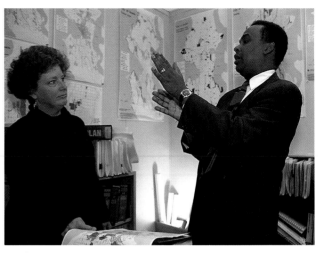

His 687-page urban plan *With a city planner*

true that a city has permanence but it is the spirit that moves from one generation to the next. That is the kind of permanence that I am interested in as Mayor."

The rain is steady as it falls on the windshield of the car taking the Mayor to a luncheon at a local Chamber of Commerce. This is the third day of what will be a seven-day stretch of clouds and rain for the Seattle area. The light outside is soft and gray, deepening the green of the pine trees that come into view as the downtown buildings of concrete, steel, and glass are replaced with the wide tree-lined streets and grand homes of the suburbs. Inside the car the Mayor pulls out the neat package that holds the printed pages of the speech for this meeting of small business owners. Reading aloud in the car, he runs through the speech, pausing at the expected laugh lines and raising his voice now and then to emphasize a thought or idea. At the conclusion he turns to his driver, a detective in the Seattle police, part of a special detail assigned to the Mayor and says, "It's boring, isn't it? Don't worry. I'll replace half of it once I get going in front of the group."

This speech, like a dozen others he will give this month, is another small link in the chain that he is trying to weave around Seattle as part

of a plan for the twenty-first century that he calls his "urban village strategy." The plan itself has been published in a six-pound, 687-page book that will probably only be read in its entirety by a few reporters, urban planners, real estate developers, and political opponents of the Mayor. Most of the citizens of Seattle will get a distilled and edited version of the plan from the Mayor at a small gathering like this or from a two-minute TV interview. The dozens of speeches and public appearances designed to help sell this plan will keep the Mayor moving nonstop through the city.

The speech that is finally delivered to the Chamber of Commerce doesn't sound anything like the speech practiced in the car. In fact, Mayor Rice barely looks at the printed text during his twenty-five minutes at the podium. It is not even boring anymore as he spells out

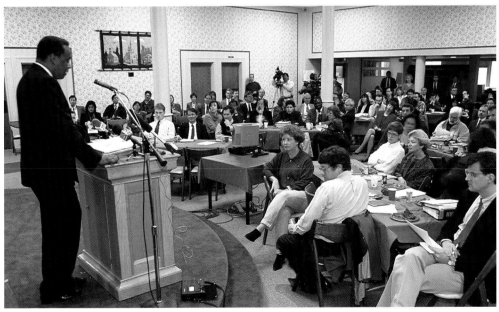

Promoting his urban plan

his ambitious vision for the future of Seattle, bringing it to life with stories that reflect on the themes of community and family, themes that define Norm Rice's view of how a city should function.

"When I was growing up I used to think that what made my neighborhood and my community a part of the city, what made it work, was the notion that everybody looked at their neighbors as family. The urban village is trying to recreate a community where everybody has concern for their neighbors as if they were their brothers and their sisters. To make the urban village strategy successful and to maintain our quality of life, we must rethink our whole notion of mobility and transportation. The elements that make a village have to be designed together in order to create areas in which people can live, work, shop,

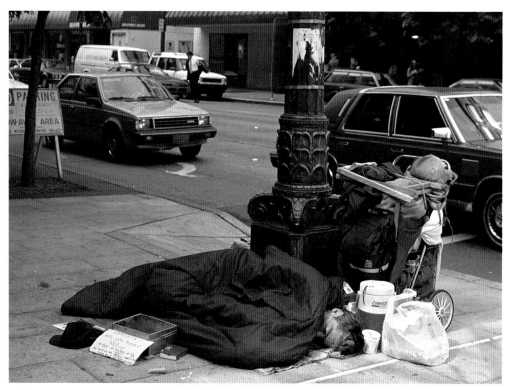

Like every other large city, Seattle faces the problem of homelessness.

play, and go to school all within walking distance of their homes. Seattle must become a city where more people live closer to work and school, where people see every neighborhood as a great place to own a home, operate a business, or raise a family. As a community, we have only two choices. We can either control growth, or we can let growth control us. I believe that we must control growth, and direct it in ways that reflect our goals and concerns as a community."

Directing his energies to Seattle's "human resources," Rice is concentrating on projects whose results are often difficult to measure. His programs and goals are designed for people, not necessarily flashy headlines or billboard slogans. His emphasis on human services, human rights, and education are in some ways very unique because they seek to affect long-term changes in society. It is always easier to come in and say, "What I want to accomplish is to have twenty more roads built, or five buildings constructed, or keep taxes level." Those are concrete and easy to measure. At the end of a term you can see whether they have been done or not. With issues like health care, education, and homelessness, the results are much harder to measure.

Although Norm Rice loves to talk on and on about public policy and the future of his city, most of his duties involve direct services which affect the people of Seattle on a day-to-day basis. These ordinary concerns can never be forgotten, no matter how exciting it may be to plan for the urban village of tomorrow. The police, fire, and garbage collectors had better be there when people need them or the phones will ring all day at the Mayor's office.

The Mayor's day starts early. In fact, Seattle city government has a long tradition of 7:30 A.M. meetings and Norm Rice notices anyone who tries to sneak in late. Several times each month he may have a 7:00 A.M. press event, like today's call-in radio show at a neighborhood studio. Arriving a few minutes early, he reads the newspaper and sips

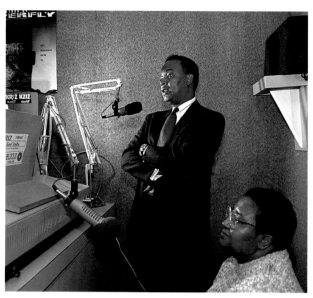

The Mayor's day starts early

Early-morning radio broadcast

his coffee, squeezing the most out of each minute of his time before he is on the air in front of a microphone. After a quick hello to the show's host, a few words wishing her well from a stumble that left her with a broken ankle, the show starts. It is two minutes after seven, most of the city is still in bed, in the shower, eating a doughnut, or sipping on a cup of expresso coffee while Norm Rice is already at work, launching into a public seminar on his "urban village strategy," explaining concepts like "controlled growth," "neighborhood centers," and "minivan shuttles." What a way to start the day! The calls come in and bring him into discussions on crime, education, and jobs. In many cases he laughs when the caller starts a question, giving a knowing smile of recognition and surprising both the caller and the talk show host by responding to the seemingly anonymous caller on a first name basis. "Who else would get up this early to yell at the Mayor? Of course I know these people."

From this radio show he will head back to his office and confront a steady stream of people who arrive on the twelfth floor of the Seattle

Municipal Building for meetings with the Mayor or his staff. While not everyone who strolls in can have a private meeting with the Mayor, his executive staff will listen to anyone from the city.

Twice a month he holds a large staff meeting for the thirty department heads that fall directly under his chain of command, including Police, Fire, Human Services, Engineering, Budget, Health, Education, Parks and Recreation, Economic Development, and City Light. The Mayor is responsible for hiring all of the people at the top and watching over the ten-thousand-person work force that keeps the city of Seattle running. His job during these sessions is to keep everybody focused and be alert to squabbles that can pop up between departments. Tension between departments is a tough problem to avoid as most people in city government, despite their dedication, work long hours and get few thanks for their efforts.

Throughout the day he will meet individually with department heads to review their projects. This means that he also must be knowl-

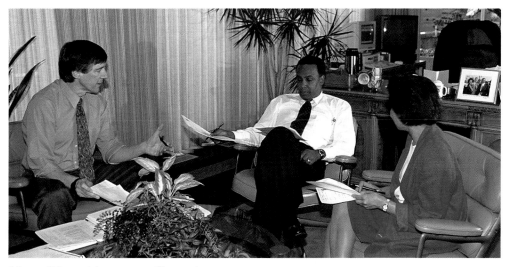

Norm Rice with some staff members

edgeable about these vastly different areas and remember thousands of details.

Meeting with water department planners to discuss future rates and distribution projections that will stretch into the year 2000 becomes a highly technical discussion with lots of graphs, charts, and numbers being studied for forty minutes without a break. One of the water planners grabs a new thick notebook to illustrate a point and stops to tell the Mayor, "I don't want to go into *too* much detail on this."

"That would be just *fine* with me," Norm Rice says, through a wave of welcome laughter.

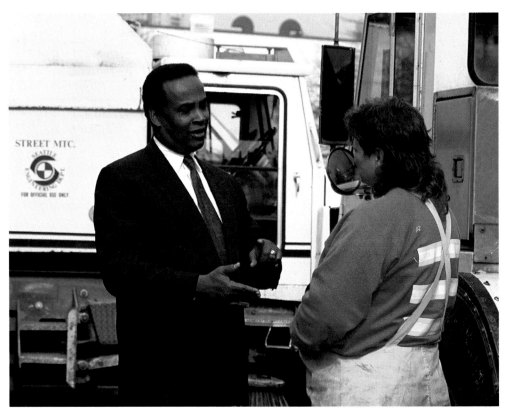

A visit to the engineering department

The real issue that the Mayor is facing in this meeting is that Seattle, like much of the West Coast, lies on a geological fault. There have been some minor tremors in recent years and they have to be ready in the event of a more powerful earthquake. With an awareness of the scientific data, underground pipes need to be reinforced and the water-distribution system has to be strengthened. A water rate increase or new taxes may be needed to pay for these improvements. This is something that won't be popular with the citizens of Seattle but may be unavoidable. This is not something that will be decided in one day. The group will continue to meet and discuss this issue as they receive and analyze new data. As the water department staff leaves the meeting room, the next group, in to discuss open spaces and a plan for a new park, slides into the still-warm chairs. Another hour will pass, this group will leave, and the public housing council will be in, filling these

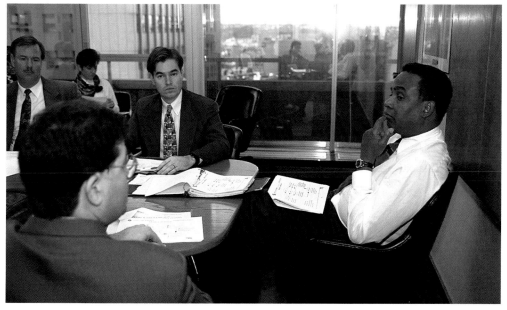

The Mayor at one of his daily meetings

chairs again. Taking a short stroll between these meetings, a staff member reminds the Mayor that he has another meeting in ten minutes with the "JEB of PIC." He sees my puzzlement and says, "Yeah, he said JEB of PIC. It stands for Joint Executive Board of the Private Industry Council. Sounds exciting doesn't it? Just another glamorous day in the life of the Mayor!"

In addition to these meetings, the Mayor will give four different speeches today, three press interviews, and attend a theater opening in the evening. Pulling his staff together, he waves his schedule in the air and asks, "Okay, which one of you is supposed to look at this and say, 'NO, this is too much'?"

After a long silence, the Mayor scans the room until one brave staff

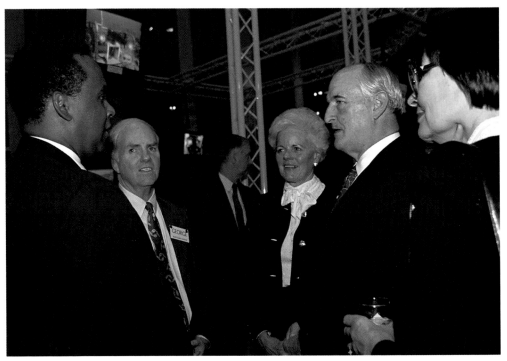

At a downtown reception

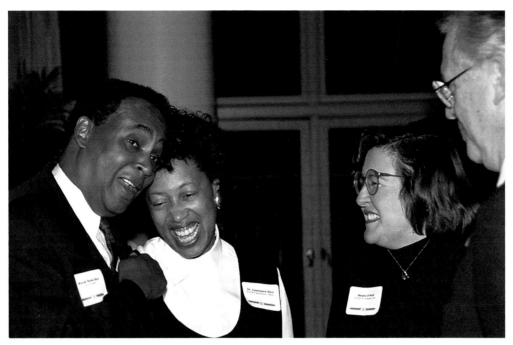

Mayor Norm Rice attending a reception with his wife, Constance.

person speaks up and says, "You are the one that is supposed to do that, Mr. Mayor," as a round of laughter moves around the room.

"Some days I am so overbooked that I don't even have time to think. Every now and then you need some quality time to think, both on the job and away from the job. I don't have nearly enough time for my family. As a public official, what suffers the most is lack of personal time with my family. I have a good son who has made me proud, and a busy, professional wife who has also made me proud. We have learned to maximize the time we have together. When you have the spare time you have to fill it with all the love and care that you have."

Returning from these meetings Norm Rice immediately throws off his suit coat and grabs a phone or switches on the computer behind his desk. (Here's a secret—Norm Rice, like many other people who look extremely busy at their computers, might just be unwinding a little

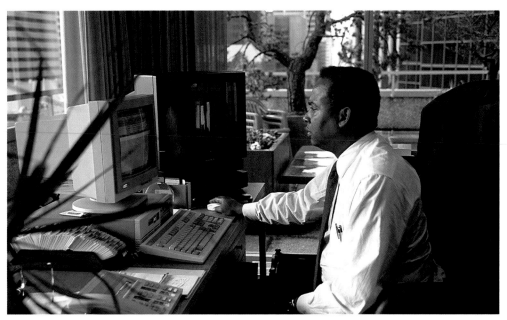

At work at his office computer

Out for a late-afternoon snack

with a game of solitaire or Tetris.) His familiar laugh often bounces through the long corridors and offices that house his executive staff as he catches up on correspondence and phone calls. Wellington Webb, the Mayor of Denver, an old friend and high school classmate is on the phone looking for sympathy as he explains the mess he has inherited as the new Denver International Airport keeps delivering the wrong luggage and construction delays keep it farther and farther behind its scheduled opening. "I am the luckiest Mayor in the United States," Rice says through laughter, as he attempts to console his old friend. Putting down the phone, he may sneak outside in the late afternoon for a snack and a can of soda, always choosing diet soda so he won't feel as bad about destroying his diet with a candy bar or slice of pizza.

He and his staff stay in touch with the Governor's office and the Washington congressional delegation to watch over legislation that will impact the city. Often federal and state grant money can make the difference in instituting a new project or program. In addition to his powerful role as top city administrator and decision maker, he is also the Ambassador of Good Will and Official Greeter for the city. He often personally welcomes convention groups and business meetings to town, and lends his office for press conferences to groups like the Seattle Sounders who hope to bring professional soccer to Seattle. Sometimes the Mayor just has to show up at ceremonies and say, "Hello." One of the most difficult of his jobs is to figure out which events he can attend as Mayor. The demands on his time are a constant battleground as the invitations pile up on his desk—dedications, dinners, schools, charity luncheons, auctions, breakfasts. For some he sends a note of regret that he cannot attend, for others he signs an official proclamation honoring the meeting or event, and for many

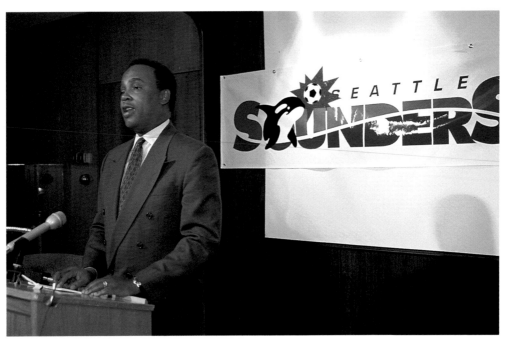

Attending a press conference to welcome the Seattle Sounders

others he says, "Yes," and juggles his already crowded schedule to fit them in.

"Isn't this the third time that we have dedicated that building?" he asks with disbelief as his scheduler explains to him that this is indeed the third dedication ceremony and presents him with the reasons why he should smile through it and speak once more as an "honored guest." He reluctantly agrees and then begs out of crowning the Greater Seattle Salmon Queen with, "Can't we just send a letter of congratulations?"

"There is no other job quite like it in the United States, to be Mayor of a city. I have been asked on several occasions to run for higher office, particularly the U.S. Senate, but I honestly believe you can make the most impact in a city. You can see changes here, see right away how things affect people. That is what makes

cities so vibrant. This job is also not without its burdens. No matter whether
something is your responsibility or not, people see the Mayor as the most visible
leader of the city. They expect you to take leadership on all sorts of things which
you really don't have any power over. The more visible that you are, though, the
more that people see you working, the more they see me out there on the streets,
well then they give support. People don't want you to have all the answers, they
just want to know that you listen, that you care, and that you are working. Of
course, there are plenty of days that I complain mightily, but I said I would be
accessible and that is what I am going to be."

Elected to his second four-year term in 1993 with 67 percent of the

No job is without its burdens

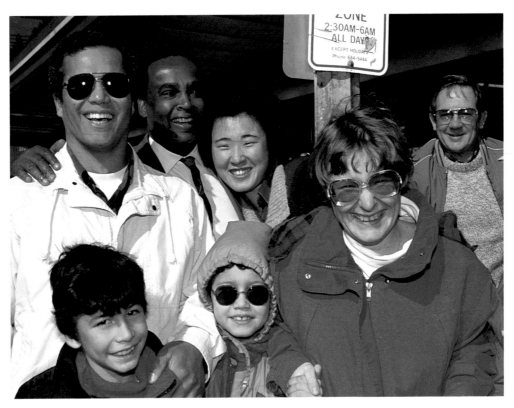

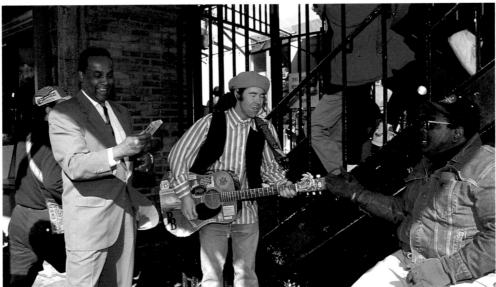

Visit to the Pike Street Marketplace

20

vote, Norm Rice knows that his success is due in part to his style, not just his ideas and actions. His easygoing, upbeat personality is part of his political strength. It is with him when he is at a table slowly negotiating a city contract or out on the streets where shouts of "Hey, Norm!" follow him like a shadow. On a Saturday afternoon shopping trip through the busy Pike Street Marketplace, he is all smiles. Well-wishers approach from all directions to shake his hand or throw an arm around his shoulder. Schoolteachers stop to talk about education and fish merchants grab him to discuss whether there will be a problem with salmon fishing this season. There is good food and music out there too, and Norm is delighted to catch a new cassette tape that is tossed to him from a sidewalk musician or sample some pastry from a bakeshop.

"This is the fun part, I love this," he says, as a visitor from Japan giggles and bows as the Mayor stops for a photo with her and her local hosts.

"I am so honored," she says.

"No, the honor is mine," he replies and adds jokingly, "Keep spending money here in Seattle. That sales tax is what keeps the city going."

"I grew up in Denver, in a middle-income, African-American family. I wasn't a great student but I was very involved in extracurricular activities. I went to the University of Colorado and I didn't do well. I flunked out after a year and a half and then I had many jobs. I worked in a hospital as an orderly. I worked for the gas company as a meter reader, then I worked as an engineer's assistant at IBM. I also did some acting during that time and I was in a play called A Raisin in the Sun. *We were doing the play during the time that Martin Luther King died and there is a line after the son loses their money and the mother is crying and says, 'God has given the black man nothing but dreams, nothing but dreams.' At that point the play stopped and we all cried on that stage.*

"That moment was a turning point in my life, that was the point where I decided that I wasn't going to dream. I was going to make my dreams come true. I decided then that I was going back to school. I packed up all my belongings in my old, beat-up car and I headed to the Pacific Northwest. I had no idea where I was going to go to school. I hadn't been accepted anywhere and I had about a hundred and fifty bucks in my pocket. I stayed with a cousin in Seattle. I got a job in the stock room at J.C. Penney's and enrolled in the local community college. Eventually I got admitted to the University of Washington and, now that I was determined, I did A work. I went on to graduate school in Public Administration and was also doing some work for the Urban League, which I wrote up as my masters' thesis. Once I completed graduate school I went to work for the Puget Sound Council of Governments and then I got a job at the Rainier Bank.

"In 1978, I was just about to the point where I had decided that this would be my career. That I would become a real banker and then a seat opened up on the Seattle City Council. It says something about this country that in 1968 somebody could come to Seattle with one hundred and fifty dollars in their pocket, then in 1978 get elected to the City Council and by 1989 be the Mayor of the city. That's pretty good!"

One can't help notice the fact that he is the only person of color at a meeting of business people or at a reception at an exclusive downtown social club. His skin color seems to play no role in his job and a decision may have as much chance to be applauded or laughed at by minority voters or white voters. Seattle is a city that takes pride in leading the country on social or environmental issues and race is not a question here.

The worst part of the Mayor's job is to be awakened at home in the middle of the night and be told that a policeman or child has been shot. Hardly a day goes by when he is not holding a meeting with police, school, and community leaders searching for ideas to cut down the rate

of violence. The Mayor knows that there are no easy answers to the growing problem of crime and violence. Cities and towns throughout the country are all grappling with the same problem.

The city of Seattle has started a number of programs to make the police a familiar, recognizable part of each neighborhood. It was the first city in America to equip police officers with mountain bikes for patrolling the streets, parks, and schoolyards. Seattle's beloved "bike cops" have become a model for over one hundred and forty other cities.

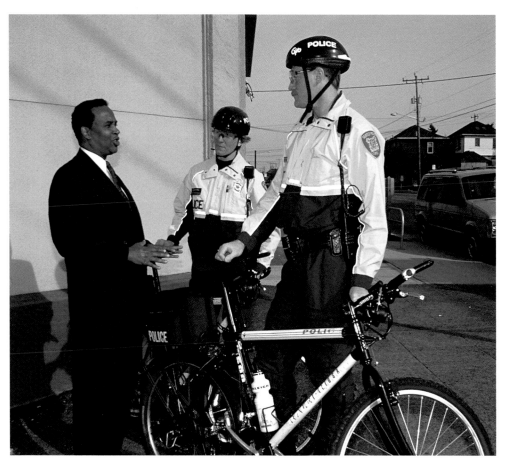

With police bike patrol

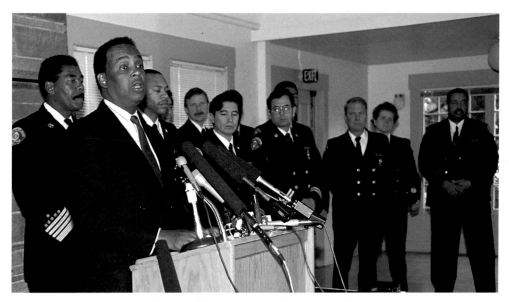

Announcing plan for police and fire personnel to live in the city

The Mayor and police chief have long believed that keeping the police and their families in the city may help to keep crime down, at least in their own neighborhoods. Working together, they have come up with a plan to help finance new homes for police or firefighters willing to live in the areas they serve, rather than commuting from the suburbs. By twisting a few arms at local banks, Mayor Rice has helped Seattle take a small step forward to make home ownership affordable without costing the city anything. The trick that Mayor Rice has learned is that it is not enough to start a new program, the key is for it to pay for itself. If something costs the taxpayers money, it will be ten times harder to get it started. There are stacks of great ideas filling the file cabinets in the Mayor's office that have never gotten off the ground because there was no money to pay for them. The question of money is always the first that he confronts. "How much will it cost?" is heard long before, "How does it work?"

"I wanted to do something with education, more than just talk about it, so I volunteered and taught communications to a fifth-grade class. I didn't realize how hard that was going to be but it was a wonderful experience to share the excitement of fifth graders. It made me see what teachers face in the classrooms. They end up having to be mothers and fathers and nurses and psychologists and counselors, it's not just teaching . . . and they need some help. The city has to be a more active partner with the schools.

"That experience in the classroom helped form my commitment to education, my fight for the money that we raised with the family and education tax levy. Today's families have changed because mothers and fathers work farther and farther away from the schoolhouse, they can't get back to school so we need

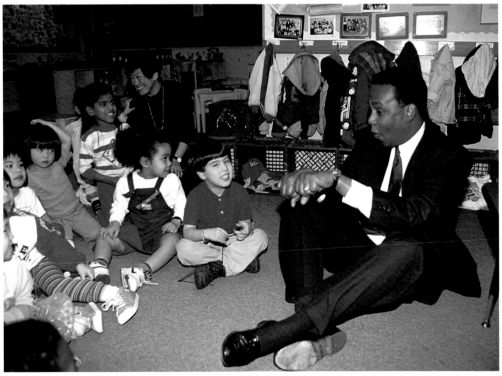

With preschoolers, recreating a visit to Africa

afterschool programs, latchkey programs, the kinds of things that reinforce community, reinforce village, and reinforce learning. These are the kinds of things that I am trying to put into place."

To convince me of this, on my last morning in Seattle, Norm Rice made a quick stop at a preschool across the street from his office. I suspect that his communication lesson here must have been a bit different than the one that he used with the fifth graders. He had been complaining all week about the jet lag that he was suffering from a recent trip to Africa. And Africa was definitely on his mind as he started to tell the kids the tales of his encounters with wild animals. His stories got more and more animated as he began to demonstrate the animals' behaviors. Within minutes he was on the floor trumpeting like an elephant, grunting like a hippopotamus, and roaring like a lion. The kids howled with delight as he led them in a grand chorus of animal noises. The teachers clasped their hands over their ears as the jungle rhythms echoed through the classroom. The communication skills needed to charm a group of well-dressed bank executives, police captains, or public works' truck drivers are perhaps tested most by winning the hearts of a group of four year olds. That, too, is what it means to be a Mayor.

Getting to Know Norm Rice

What do you like to do for fun?

Play tennis and read.

What relaxes you the most?

Watching action television and cooking. Most of the home-cooked meals at our house are the ones that I have made.

What are your favorite junk foods?

Baloney and salami.

What are your favorite things to spend money on?

Clothes, books.

What is your favorite part of the job?

Meeting new people.

What do you miss doing now that you can't do because you are a Mayor?

Putting on my grungiest clothes, being casual, and slipping into a crowd unnoticed.

What don't you miss?

Boredom.

What is your favorite movie?

To Kill a Mockingbird

Who are your favorite movie stars?

Denzel Washington, Julia Roberts, Kenneth Brannagh, Emma Thompson, and I think Halle Barri is cute.

What music do you listen to?

Jazz.

What are your favorite books?

Hie to the Hunters *by Jesse Stuart,* Lord of the Flies *by William Golding.*

Who are your best friends?

My wife and my son.

When you were a kid did you want to be a Mayor?

I wanted to be an elected official. I always felt that there was something destined for me to do.

What would you like to do next?

I want to do the best job that I can as Mayor. At some point, I would like to seek higher office. I don't know what, but I think if I do a good job as Mayor, my future will take care of itself.

MORE FACTS ABOUT THE MAYOR

The Mayor's office has a staff of twenty, nine policy assistants and eleven support staff.

The Mayor gives fifteen speeches per week.

The Mayor has fifty to sixty meetings per week.

The Mayor's office receives 150 letters and 500 telephone inquiries per week.

Each day about twenty-five people drop by the Mayor's office. Most of them meet with a staff person before their issue is brought to the Mayor.

The Mayor works at least six, often seven, fourteen-hour days, each week.

The Mayor meets several thousand people each week, at least 100,000 over the course of a year.

The Mayor tries to play tennis twice a week.

The Mayor signs 500 proclamations each year.

Norm Rice cooks dinner twice a week at home for his family.

MORE SEATTLE FACTS

The city of Seattle has 10,540 employees, including 1,770 in the Police Department, 1,105 in the Fire Department, 994 in Parks and Recreation, and 372 in the Libraries.

The population of Seattle is 527,000.

The city covers 88 square miles.

The Port of Seattle is the #1 U.S. port in container tonnage exports to Asia, and one of the largest ports in the world.

The Seattle city budget comes from monies collected from property taxes, sales tax, hotel occupancy tax, business tax, and government grants. The total budget is 1.5 billion. This includes the city-owned utility company, which provides electricity and water—1.1 billion covers these utilities, 400 million is the budget for all other city services.

ACKNOWLEDGMENTS

First of all, it only rained twice while I was in Seattle, so I know I have to be thankful for that!

Louis and Lorne Richmond helped to pave a clear path for me in Seattle and introduced me to my hosts at The Edgewater Inn, The Seattle Sheraton, and the Alexis Hotel, who were gracious enough to house me during my stays. I am happy to have them as new friends.

U.S. Secretary of Commerce Ron Brown and Deputy Secretary Bill Morton provided me with an initial introduction to Mayor Rice and helped to promote the idea of this book.

Mayor Rice's staff opened up their office doors and allowed me free access to their meetings and conferences. I thank Laneyse Cippola, Mark Murray, Rebecca Hale, Jerry Arbes, David Bley, Frances Carr, Joe Bouffiou, Percie Hill, Donna James, Cyril Juanitas, Anne Levinson, Robert Watt, Rodrick Brandon, and a special thanks to Andrew Lofton, who moved on to a new job just in time to give me his office.

For their support throughout this project I wish to thank Josh Rubenstein, Jill Janows, Art and Betty Bardige, Catherine Hayden, David Thurston, Governor Ann Richards, Senator Connie Mack, Steve Brettler, Louisa Kasdon, Steven Krensky, Nick Mitropolous, Ginny Terzano, Rosanne Lauer, and Roscoe Undermayer.

Norm Rice welcomed me into his life even though he had just flown thirty hours home from Swaziland, even though his schedule was too crowded, even though he was fighting a cold, and even though he was bone tired . . . I never noticed. For all of his courtesies, patience, indulgence, and thoughtfulness, I am grateful. In fact, we might do this again someday.

𝒦